Dreaming Pictures
Paul Klee

Prestel Munich · New York

Why is he so strange

"A devil in lots of different colors coming out of the dark"

"Standing there, absolutely still, like a wooden doll"

*"Any moment now, his round head is going
to roll right off his neck"*

But what is he actually doing?

"He looks so funny with just one eye"

"Maybe he is bowing to the audience"

The actor steps out of the dark to the front of the stage.
The darkness makes the red, yellow, and white of his
clothes seem even brighter.

Poised above a triangle, his head threatens to roll off at
any moment.
His feet, on the other hand, are planted firmly on the
ground.

The figure is made up of simple, basic forms: rectangles,
triangles, circles, and semicircles.
The patterns on his clothes and their subtle colors make
him look a little less stiff. Nevertheless, this actor is hard-
ly acting at all.
While he looks at the audience with one eye, it seems as
though he is looking inside himself with the other.
The longer you look at this picture, the more you begin to
wonder: What's the story here?

The Actor

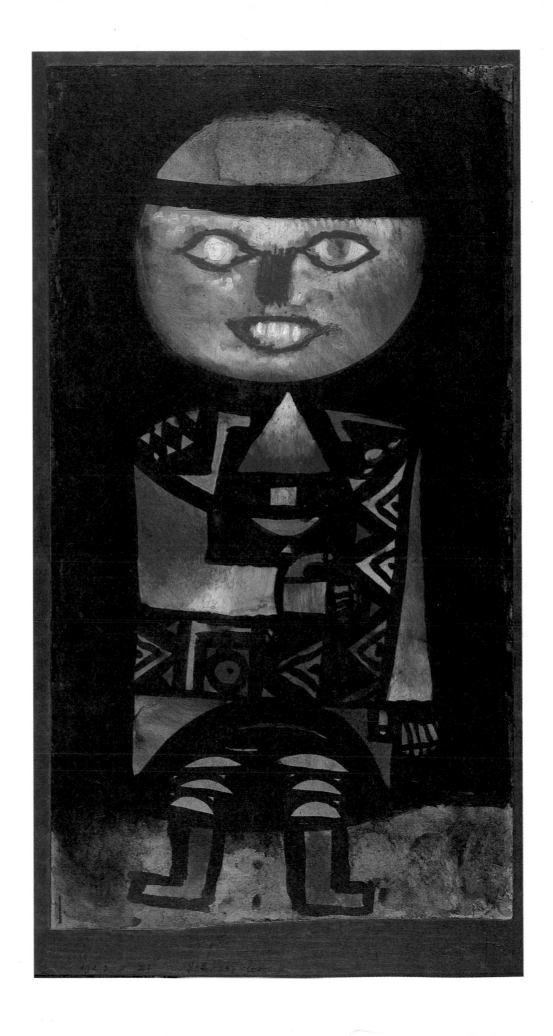

It's almost all red

"A fight in hell"
"Rockets in a fire-storm"

You can't paint wind. But you can draw lines to show how the wind moves.

It seems as though we can actually hear the wind whistling around the rose in the middle of the picture, doesn't it? Arrows shoot in all directions like rockets, letting us see how strong the wind is.

Fine lines packed together around the rose let us "see" the rushing wind. And the circular petals of the rose itself seem to be drawing the wind right into their center.

There is something threatening about the black shapes in this picture. The rose has all its thorns out to defend itself. It does not grow solidly in the earth, but seems to float above its pot.

This is one of many pictures in which Klee managed to paint something that nobody can actually see.

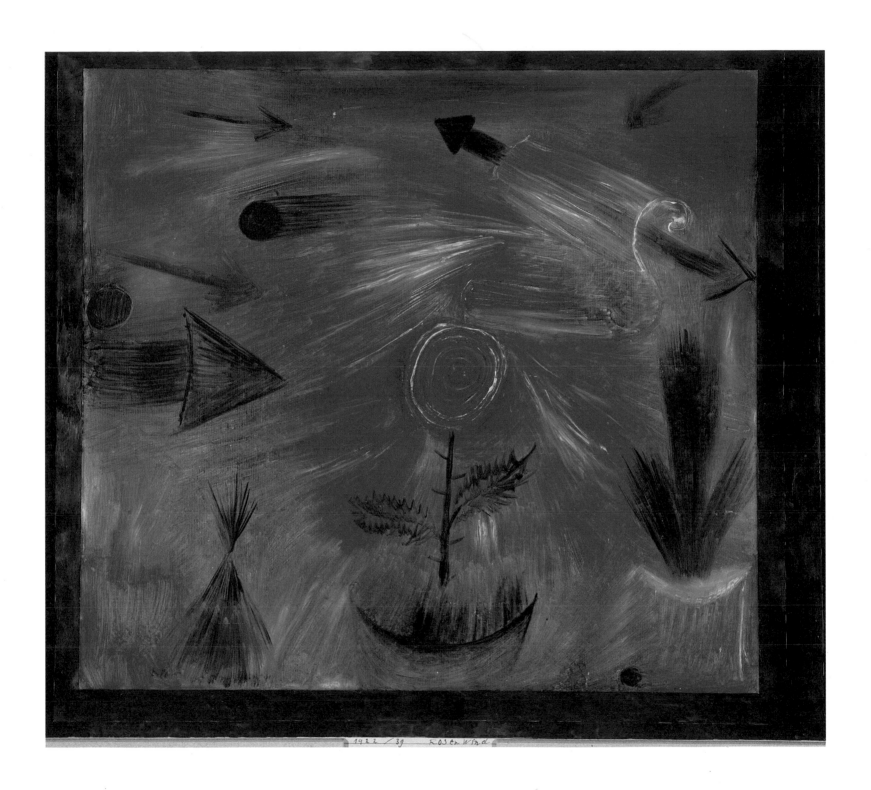

1922 /39 Rosen Wind

Young Woman

Look at her!

"Looks a bit sad"

"Someone wearing make-up and light summer colors"

This "spot-the-young-woman picture" was done in thin, watery paint.
It shows a pale young woman against a hazy background.

The distinguishing features of this face are one oversized eye, a squashed nose, and a rather small mouth.

We are mesmerized by her slitlike, half-closed eye.

Her rounded, stooping, witchlike back matches her bad-tempered scowl.

Chance clearly played a part in this picture, which Klee constructed out of finely outlined pools of color.

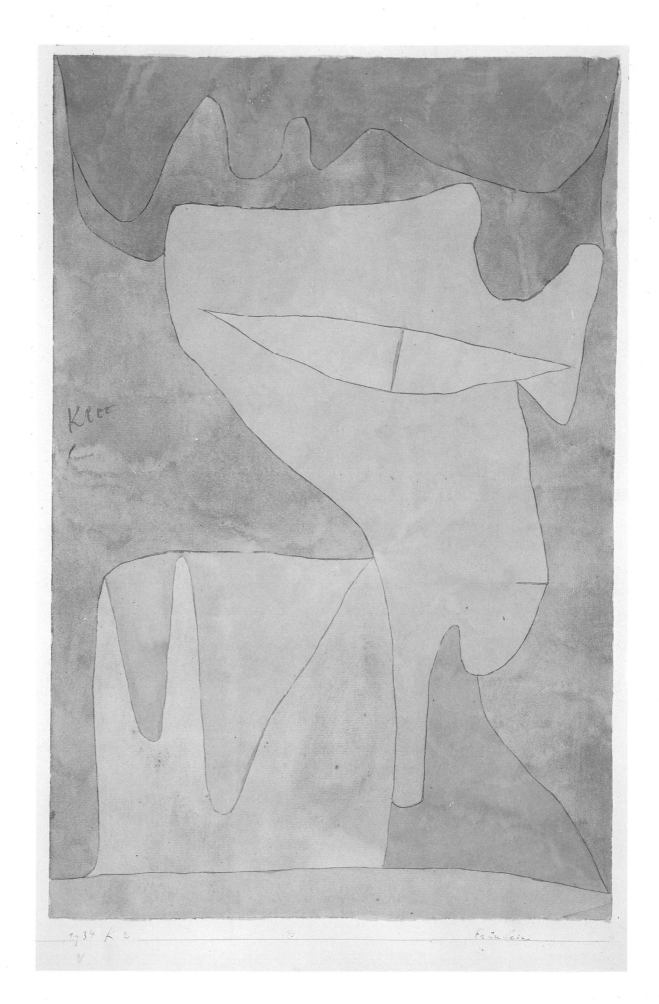

See what you see round the corner

"A spider in a wild garden"

"A creepy night in the garden"

A very leafy kind of picture. Things all over the place, as if in a room that hasn't been tidied up.

Bushes and trees are just sketched in with short, pale brush strokes.
You can also see lots of windows and parts of houses: natural and human things jostling one another.

A large, round, pale yellow shape with white branches coming out of it like rays stands out from the rest of the picture.
All over the place, there is a mesh of fine white lines breaking through the darkness.

The more you let your eyes wander around this old garden, the more it comes alive.

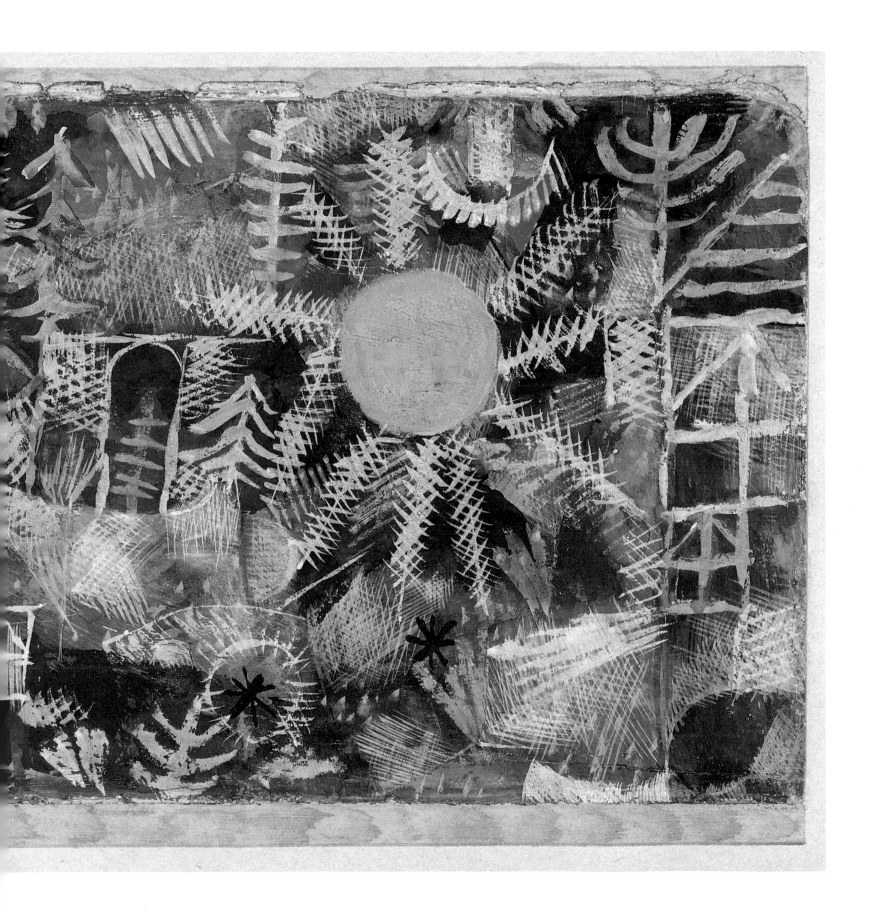

Girls' Class Outside

Who can tell what's what?

"Lots of faces"

"The yellow one looks like a duck"

The colors in this picture glow like flowers in a meadow, and it is only the dark lines that give this riotous carpet of colors some kind of order.

When there is exciting news in a class full of girls, you can't hear yourself think. You can't make out individual voices any more — to some people, it sounds like gaggling geese enjoying themselves in a sunny field.

The longer you look at this picture, the more the dots look like eyes and the lines look like noses, mouths, and faces — all happily huddling together!

Klee's clever combination of glowing colors is as bright and lively as a class on a school trip.

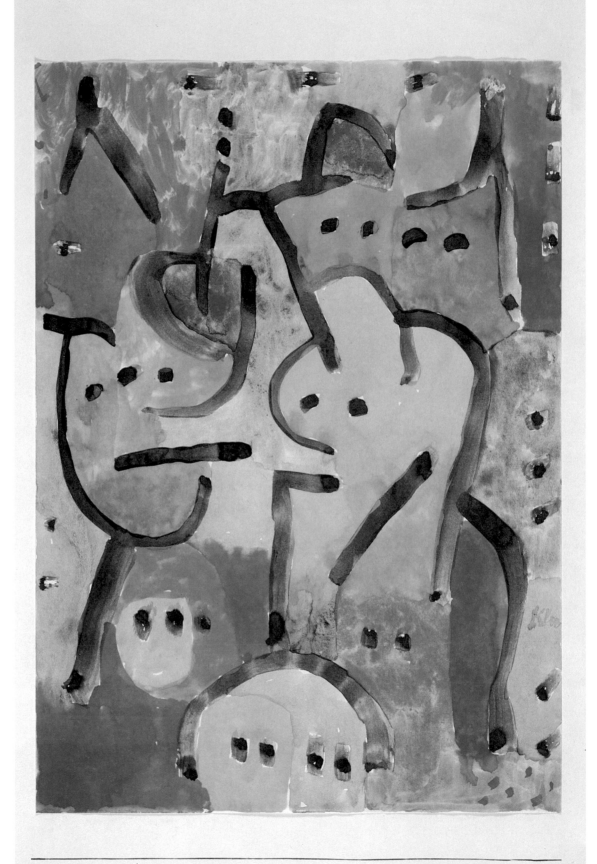

1939 AA3 Mädchenklasse im Freien

But where is the brook?

"It looks like a board game to me"

"Could you call it a Technicolor dream garden?"

Yellow, red, green, and a little blue. These are the only colors used in this bright picture.

Because Klee used very thin watercolor paint on white paper, the colors almost seem like lights.

This impression is increased by the black lines and the contrast between the "warm" colors, red and yellow, and the "cold" colors, green and blue.

Maybe the gray-blue sections above and below the garden are the brook. Or has it dried up, leaving only the two puddles in the middle of the picture?

There are so many flowers that Klee did not paint them all individually — although there is one special flower with a long stem standing alone in the middle of the garden.

Our eyes travel easily along the straight fields. Then in the middle of the picture, they stumble and tumble from one flower bed to the next.

Klee shows a sea of colored flowers as though you were looking down from a plane, like different fields separated by fences and ditches.

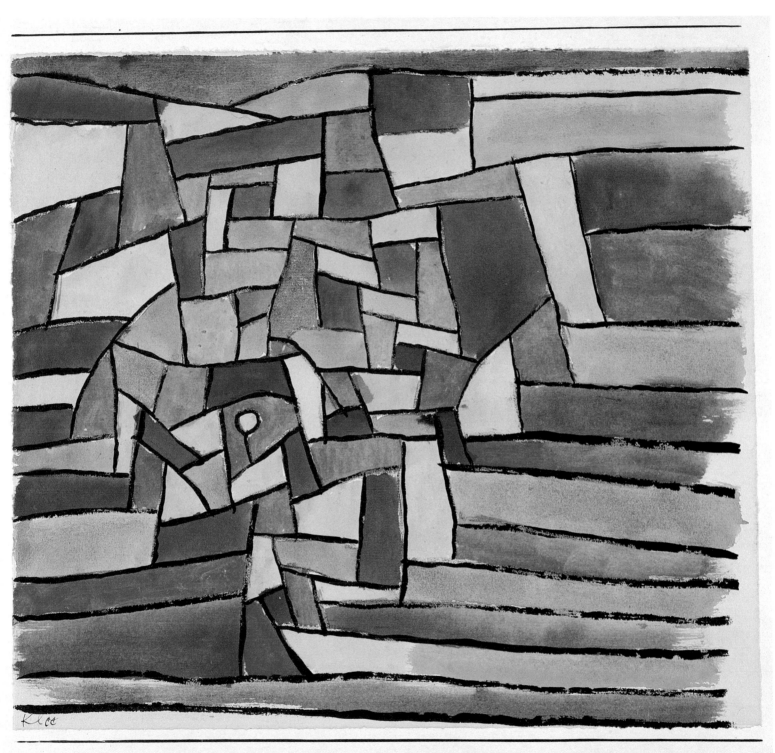

Klee

1927 V 10. Garten am Bach

Who would like to look like this?

"Like a devil with a long nose"

"A huge honker like an anteater"

"Squinting like crazy"

Who would want to meet this man?

"His nose really reminds me of"

"His lip sticks out"

"And the look on his face is like"

Here Klee has made a person out of just a few doodles.

The jutting chin and long lower lip tell us that this is a loudmouth.

Most likely, this man is very good at poking his huge, pointed nose into all sorts of other people's business.

Inside his head, his thoughts rush around so fast that they have made his hair curl.

Maybe talking a lot is the only way he can stop himself from being completely submerged by the brown background.

Man with a Big Mouth

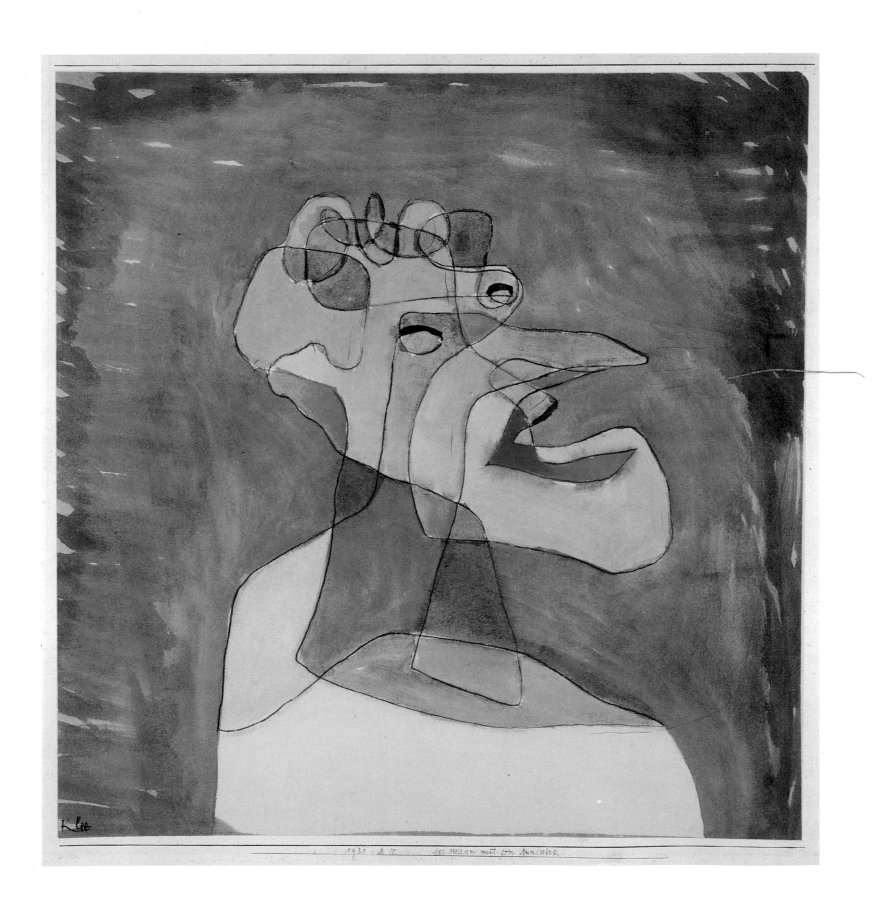

1930 der mann mit dem mundwerk

Reckless Haste

Where can he be going?

"A stick-man ghost running through thorny bushes"

"Skinnymalinky Longlegs in a forest of spaghetti"

No one will be able to stop him in a hurry.

If only all the black and red lines wouldn't get in each other's way.

Great big steps: the way the stick-man is running stands out against the framework of lines.

With his arms up in the air, he tries to push away the lines closing in on him.

The arrow above his head points: "This way!"

The red wheel below, stuck between two vertical lines, seems to be turning all by itself.

And there is another wheel just like it, where the running man's face should be.

If we run around blindly, we don't get anywhere; we just go around in circles.
Maybe the stick-man has not heard the saying: "More haste, less speed."

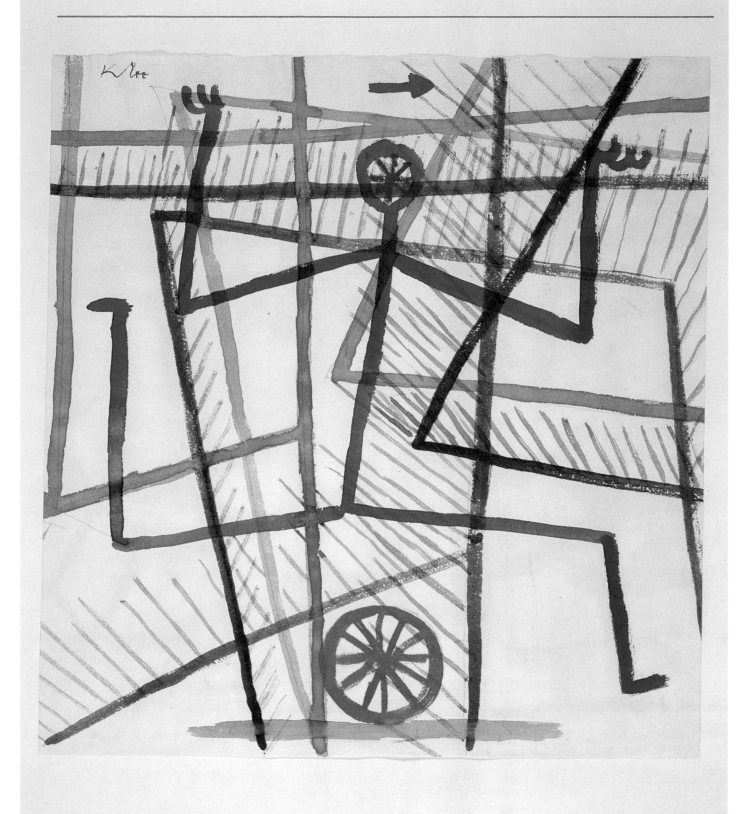

1935 N 7 Eile ohne Rücksicht

If you look at this long enough, you will start to see things
"A gate to hell" "A maze with an entrance to the depths
below...." "How can I paint on a flat surface so that things look
as though they are going right down into the depths?" Maybe
this, or something like it, was the question Klee wanted to
answer in this picture. When you first look at it, all you can see
are rectangles, irregular rectangles, and triangles. But the
picture does not look flat. Different areas of color come for-
ward or recede into the background. The warm red and red-
brown seem to be closer to us than the cold blue. Bright colors
 come closer than black or gray. The
 irregularity of some of the rectangles
 makes the feeling of closeness and
 distance even stronger. The black
 form at the center of the picture
 stands out strongest of all, and
 we find ourselves looking right
down into the depths.

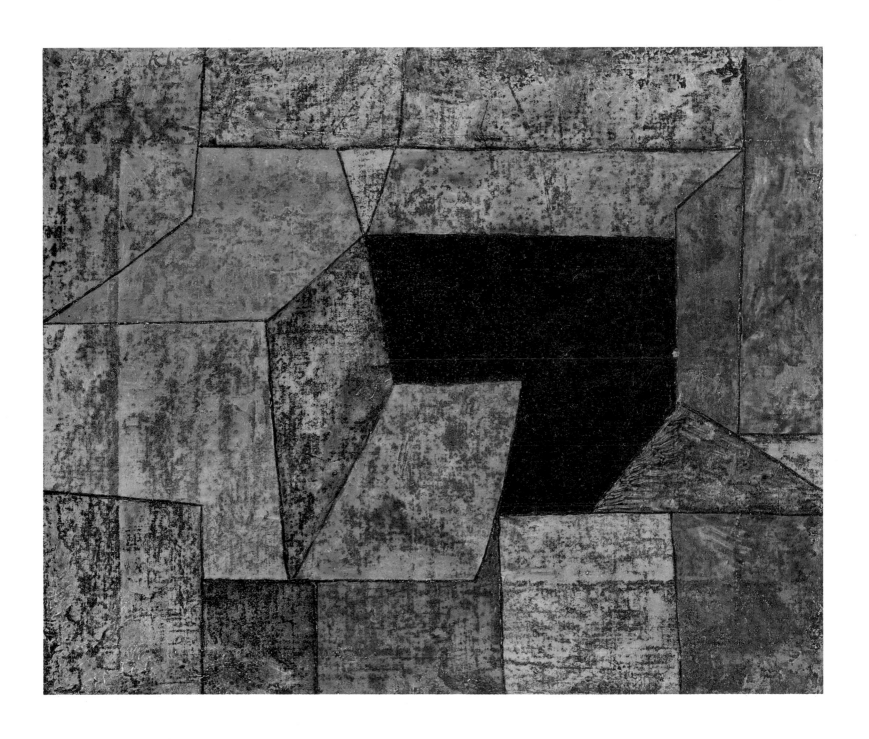

But it's almost all yellow

"Fantasy animals in a bath of honey"

"Animals hiding in a field full of yellow flowers"

What goes with what here? Is it "snake-birds"
hiding behind "catophants?"

In the top right-hand corner, a one-eyed cat
with pointed ears is turning its head.

Does the body below the cat's head belong
to the cat or to the dreaming elephant
in the middle?

There is a small animal moving about in the
stomach between the elephant's head and the
cat's head — could it be a baby animal?

The face at the left with a big,
long nose and a puckered
mouth also has only one
eye. It looks more like a
person's face than an
animal's head.

What does it
all mean? —
Whatever
you like!

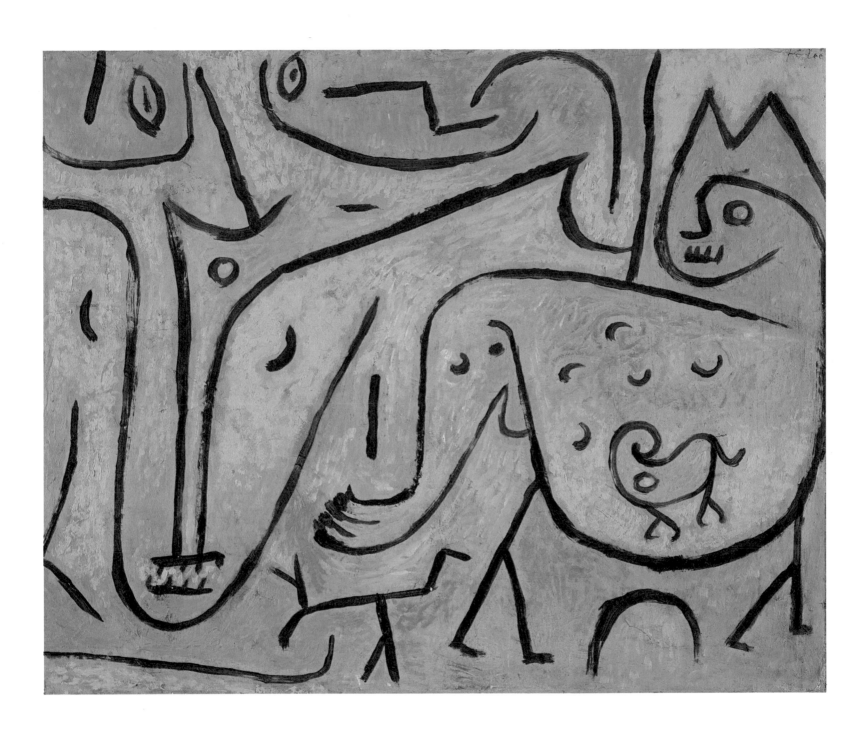

Why is she crying?

"Her mouth is laughing, but her eyes are crying"

"Looks like a sad bride with a veil on her head"

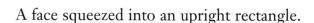

A face squeezed into an upright rectangle.

A woman with her head down between her shoulders and her arms folded across her chest.

Her mouth is open — is she laughing?
But there are three tears that show she is crying.

You can see her posture and the expression on her face in different ways. At first, all you notice is her sadness. But then there seems to be something stubborn about the way she has her head drawn in, about her mouth, and about the way her arms are folded.

By making one half of the face brown-white and the other blue-white, Klee shows very clearly the contradictions in the weeping woman's expression.

Weeping Woman

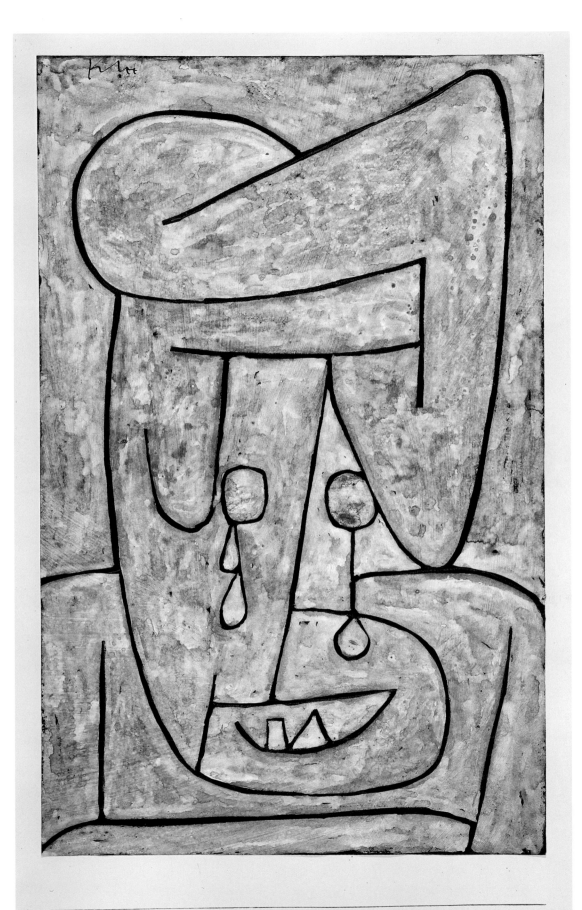

1939 XX 4 weinende Frau

Child's Play

What's
wrong with her
left eye ⸮

"She looks so serious"

"A sad-looking girl hopping"

A girl in a yellow dress hops
into the picture from the left.

She has her arms stretched out
so she won't lose her balance.

In the bottom right-hand corner, there
is a bit of meadow with flowers in it.

The hopping girl looks very serious with her
brown, sightless eye and her straight mouth.

A spiral, a heart, two rectangles with triangles stuck on to them, and two little rectangles are also flying around.

Maybe the wavy line on the rectangle where her other eye should be is a back-to-front question mark asking us to solve the mystery of this child's game.

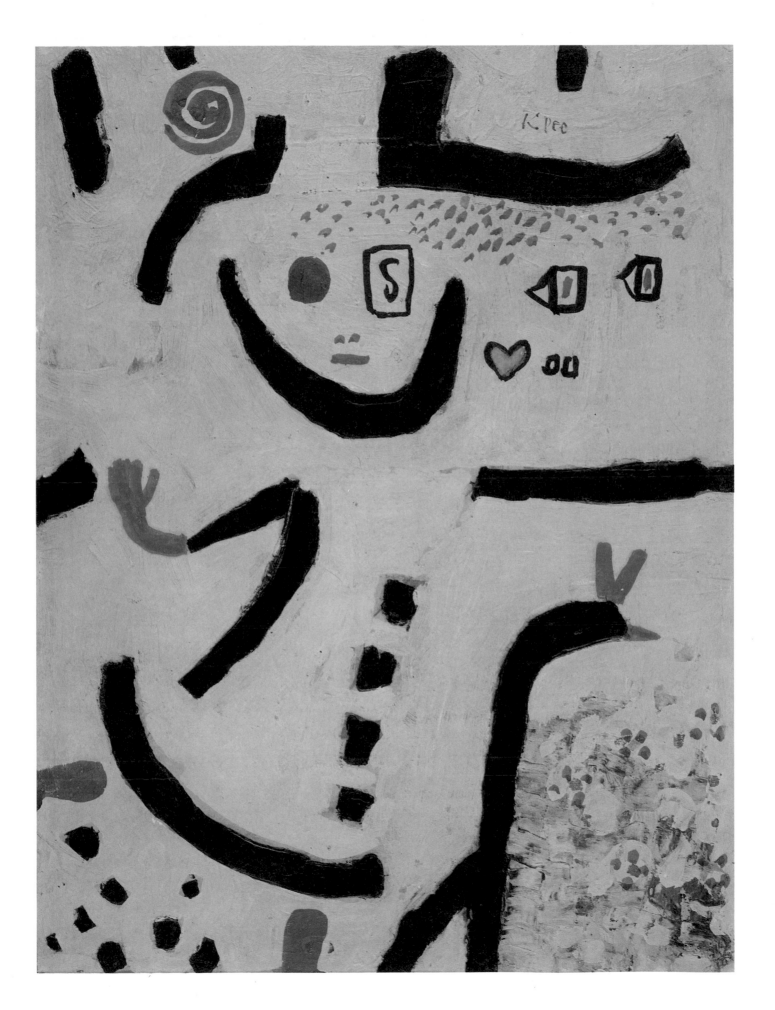

Is **this** a flower?

"A woolly creature and a flower"

*"A dinosaur in the water picking
a flower"*

You have to look at this picture for a long
time because there is so much blue that it is
hard to find the flower. The center of the
picture is taken up by one large leaf that
probably belongs to the flower in the bottom
right-hand corner.

But it doesn't really fit the flower at all — it
looks much more like an animal. Its power-
ful shape and the zigzag line along the edge
make it look like it can move.

There are hints of more flowers. Klee pain-
ted all the shapes as black outlines against
the blue background — at least that is all we
can make out, just like on a dark night.

At night, many things in nature look differ-
ent or strange or mysterious, and some-
times the leaves moving in the wind turn
into mythical creatures.

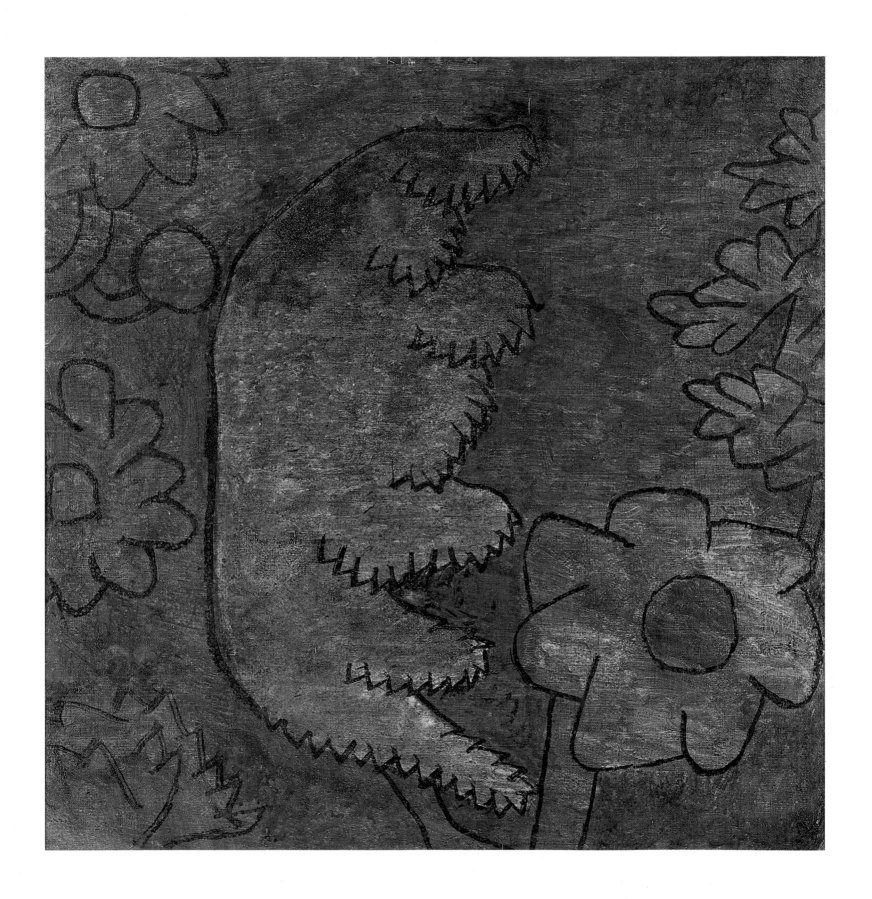

Do angels exist?

"An angel looking for a way out of the smoke"

"A bit dirty for an angel"

An angel with a round head, golden-blond
hair, and a triangular body. You can't see her
wings, but in a way her body looks like a wing.

The angel is feeling her way through the dark, waving her
arms. She almost seems to be caught in the black smears and
streaks. She is fighting against the darkness with all her strength.

Angels are creatures between heaven and earth. Although they have human
bodies and can move about on earth like we do, they also have wings.

But angels are like our fantasies and dreams: we can never grab hold of them — and, as
here, it was the things that only exist in our thoughts and dreams that Klee loved to paint.

**Angel,
Still
Groping**

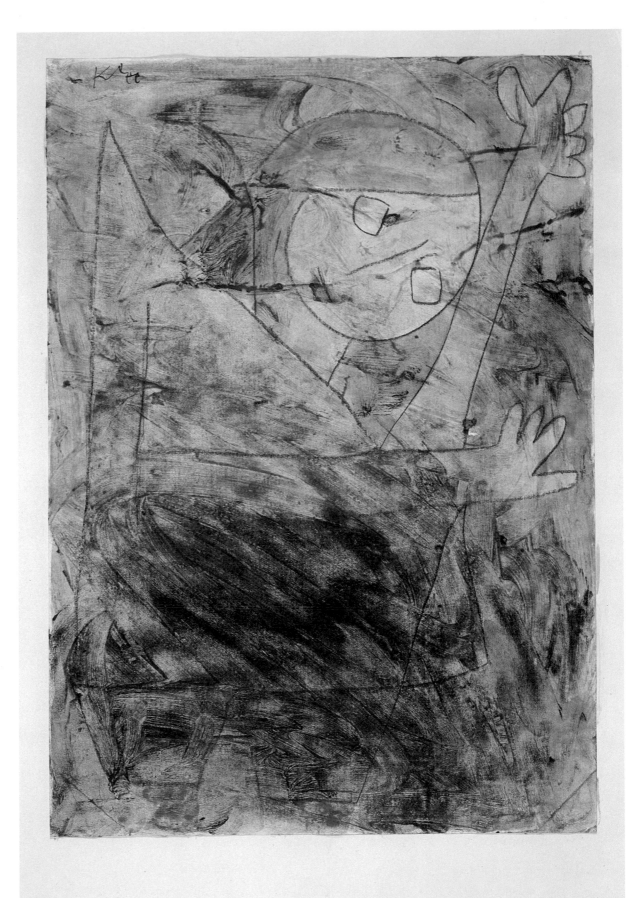

1939 MN 13 Engel, noch tastend

"I Spy with My Little Eye!"

"Art does not portray the visible, it makes things visible." Paul Klee

Anyone who looks closely at Klee's pictures will find many things painted differently from the way they appear in the everyday world.

With his pencil and his paintbrush, and even with his camera, Klee studied the endlessly varied shapes, lines, and colors of plants, animals, and people. Using a microscope, he even observed things that are not visible to the naked eye.

But as he drew and painted from nature, he felt more and more strongly that drawings, paintings, and photographs only show a part of reality. They only show outer surfaces and their details. Klee wanted to express more in his pictures than the things we can see on our own. He wanted to show our feelings, our experiences, and our dreams.

Sometimes, we present a happy face to the world, sometimes a sad one. If we have a particular destination, we see things quite differently from when we are just wandering about. Nothing stays the same forever. Plants, animals, and people grow and develop. Children become adults. Everything alive is constantly moving, whether quickly or slowly.

Paul Klee as a small child, 1881

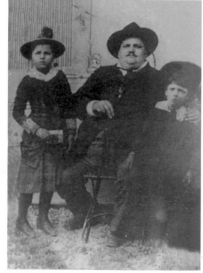
With his uncle, the fattest man in Switzerland, 1886

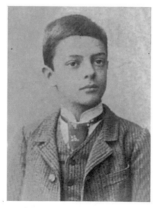
As a twelve-year-old, 1892

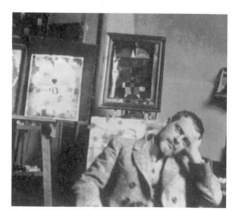
In his Weimar studio, around 1922

In our dreams, we experience things intensely, and sometimes fantasy pictures grow out of a mixture of real events and things we have only dreamt about.

Klee was fascinated by this, and he invented pictures with lines, shapes, and colors that really seem to be alive.

So we can go for walks in his pictures with our eyes. We can follow the run of the lines, link up different shapes with each other, or discover how the colors contrast and harmonize with each other. Anyone who takes the time to do this will find more and more in his pictures.

Music was very important for Klee; he was already learning the violin when he was seven years old. In some of his pictures, he makes us "hear" the shapes and colors as clearly as the notes in a piece of music.

He often invented titles for his pictures in the way that a poet might. And, like poems, his pictures put a whole series of new ideas into our heads.

In his art, Klee makes the hidden visible.

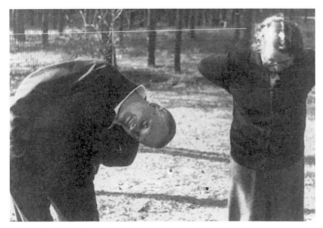

Klee and his wife Lily doing gymnastics?
1933 in Dessau

Klee with his cat Bimbo,
Bern 1935

Klee looking at his picture
Mountain Railway, *1939*

List of Illustrations

All paintings illustrated are the property of the Klee family.

Cover:
With the Sinking Sun, 1919, 247, watercolor on paper prepared with chalk, 7 ⅞ x 10 ¼ in. (20 x 26.2 cm); size of cardboard: 12 ¾ x 16 ⅜ in. (32.5 x 41.7 cm)

Without light there can be no colors. They disappear gradually with the sinking sun. In this painting the sun transforms nature into large fields of color from blue to gray.

The Actor, 1923, 27, oil on paper, 18 ¼ x 9 ¾ in. (46.5 x 25 cm); size of cardboard: 20 ½ x 11 in. (52 x 28 cm)

Rose Wind, 1922, 39, oil on paper, 15 x 16 ½ in. (38.2 x 41.8 cm); size of cardboard: 18 ⅞ x 20 ⅞ in. (48 x 53 cm)

Young Woman, 1934, 22 (K2), watercolor and pencil on paper, 18 ⅞ x 12 ½ in. (48 x 31.5 cm); size of cardboard: 25 ⅛ x 19 ¼ in. (64 x 49 cm)

Growth in an Old Garden, 1919, 169, watercolor on paper prepared with chalk, 5 ½ x 8 ¼ in. (13.8 x 20.9 cm); size of cardboard: 8 ¾ x 12 ¼ in. (22.4 x 31.4 cm)

Girls' Class Outside, 1939, 503 (AA3), watercolor and gouache on paper, 11 ⅝ x 8 ⅛ in. (29.5 x 20.8 cm); size of cardboard: 19 ⅝ x 13 ¾ in. (50 x 35 cm)

Garden near a Brook, 1927, 220 (V10), ink and watercolor on paper, 10 ⅞ x 12 in. (27.5 x 30.6 cm); size of cardboard: 18 ⅞ x 25 ¾ in. (48 x 65.5 cm)

Man with a Big Mouth, 1930, 40 (M10), ink, pencil and watercolor on paper, 17 ¼ x 16 ⅞ in. (43.9 x 43 cm); size of cardboard: 19 ½ x 22 ⅝ in. (49.5 x 57.5 cm)

Reckless Haste, 1935, 97 (N17), charcoal and watercolor on paper, 12 ⅜ x 11 ¼ in. (31.3 x 29.8 cm); size of cardboard: 25 ½ x 18 ⅞ in. (65 x 48 cm)

The Gate to the Depths, 1936, 25 (K5), varnished watercolor on cotton, 9 ½ x 11 ½ in. (24.1 x 29.2 cm)

Animals Meet, 1938, 111 (H11), oil and paste with paint on cardboard, 16 ½ x 20 ⅛ in. (42 x 51 cm); size of cardboard: 17 x 20 ½ in. (43.2 x 52 cm)

Weeping Woman, 11934, 904 (XX4), watercolor, tempera and ink on paper, 12 ⅞ x 8 ¼ in. (32.8 x 20.9 cm); size of cardboard: 19 ⅝ x 13 ¾ in. (50 x 35 cm)

Child's Play, 1939, 385 (A5), paste with paint and watercolor on cardboard, 17 ⅛ x 12 ⅝ in. (43.5 x 32 cm)

Blue Flower, 1939, 555 (CC15), watercolor and tempera on cotton prepared with oil on plywood, 19 ⅝ x 20 ⅛ in. (50 x 51 cm)

Angel, Still Groping, 1939, 1193 (MN13), greasy chalk, paste with paint, and watercolor on paper, 11 ⅝ x 8 ⅛ in. (29.4 x 20.8 cm); size of cardboard: 19 ⅝ x 13 ¾ in. (50 x 35 cm)

Photo Credits

Photographs have been kindly provided by the Bildarchiv Felix Klee, Bern. Preceding pages, from left to right: F2 no. 10, F4 no. 8, F1 no. 7, F6 no. 5, F49 no. 29 (detail, Photo Fee Meisel), F49 no. 21 (Photo B.F. Aichinger), F67 no. 6 (Fotopress W. Henggeler)

Text by Jürgen von Schemm
Translated from the German by Fiona Elliott

Both author and publisher would like to thank Manfred Fath, Director of the Kunsthalle Mannheim, Germany, for the generous and enthusiastic support he provided for this project.

We would also like to thank the students of grade 4a at the Johann-Peter-Hebel-Schule in Mannheim, and their teachers, Doris Wolf and Claudia Hohenadel, for their support.

Prestel books are available worldwide. Please contact your nearest bookseller or write to either of the following addresses for information concerning your local distributor:

Prestel-Verlag, Mandlstrasse 26, 80802 Munich, Germany
Tel. (+49-89) 38 17 090, Fax (+49-89) 38 17 09 35
and 16 West 22nd Street
New York, NY 10010, USA
Tel. (212) 627-8199, Fax (212) 627-9866

Typeset and designed by Maja Thorn, Berlin

Lithography by Eurocrom 4, Villorba (TV)
Printed by Aumüller Druck KG, Regensburg
Bound by MIB Conzella, Pfarrkirchen

Printed in Germany
Printed on acid-free paper
ISBN 3-7913-1875-6